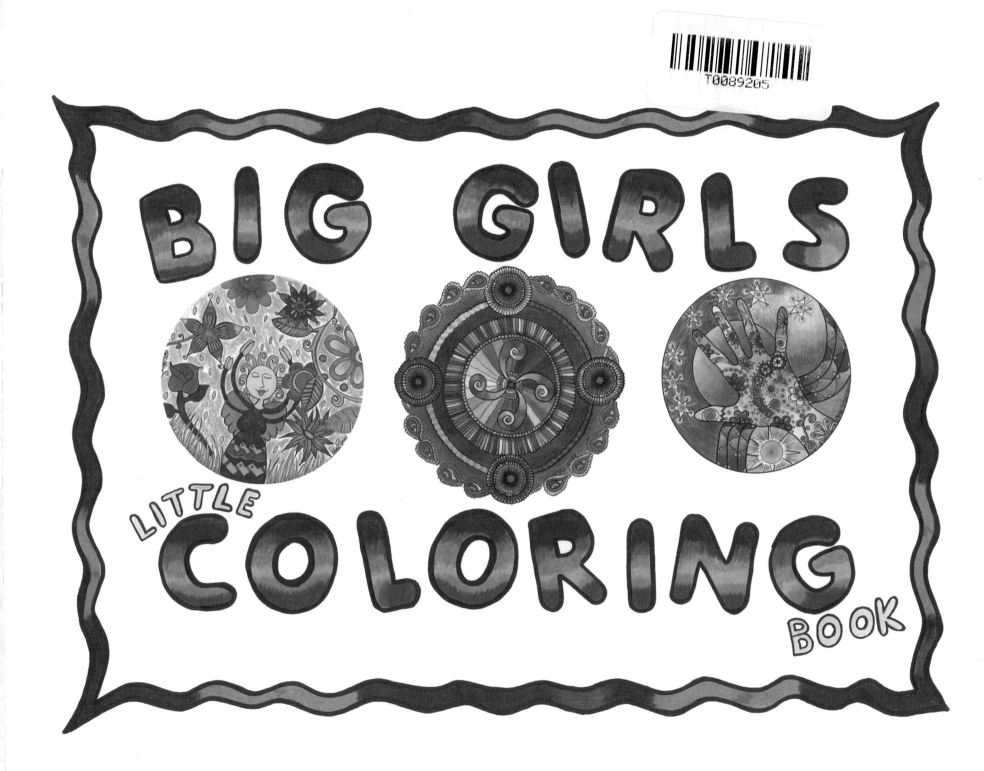

BIG GIRLS
LITTLE
COLORING
BOOK

Welcome to **THE BIG GIRLS LITTLE COLORING BOOK**

I am delighted to share the following twenty-one mandalas with you, and I am sure you will get as much pleasure coloring them as I did creating them for you!

They can be colored by starting at the beginning and working through the book or by choosing one according to the affirmation, the story, or the image that appeals to you. As a life coach I am always delighted to see how quickly people relax and breathe deeply when they enter into the creative space and the role that creativity can play for creating change and visualising new possibilities.

Mandala is a Sanskrit word for "circle," and in the twenty-first century world of concrete, technology, and complexities, returning to the circle that mirrors the womb of creation provides a time for rest, reflection, relaxation, and fun! Coloring mandalas is an open-eyed meditation, a massage for the mind, body, and spirit. You can enjoy coloring them alone or you may like to host a Big Girls Little Coloring Circle and share a creative afternoon with friends.

Thank you and enjoy the mandala magic!

—Carol Omer

*My thoughts pollinate the ether and the seeds of my intentions
grow in the garden on my life.*

Thoughts are powerful, electrical currents that influence both the inner and outer world.

Some thoughts are like weeds that need to be uprooted and thrown away, and other thoughts like I can do it will enrich the garden and seed new growth.

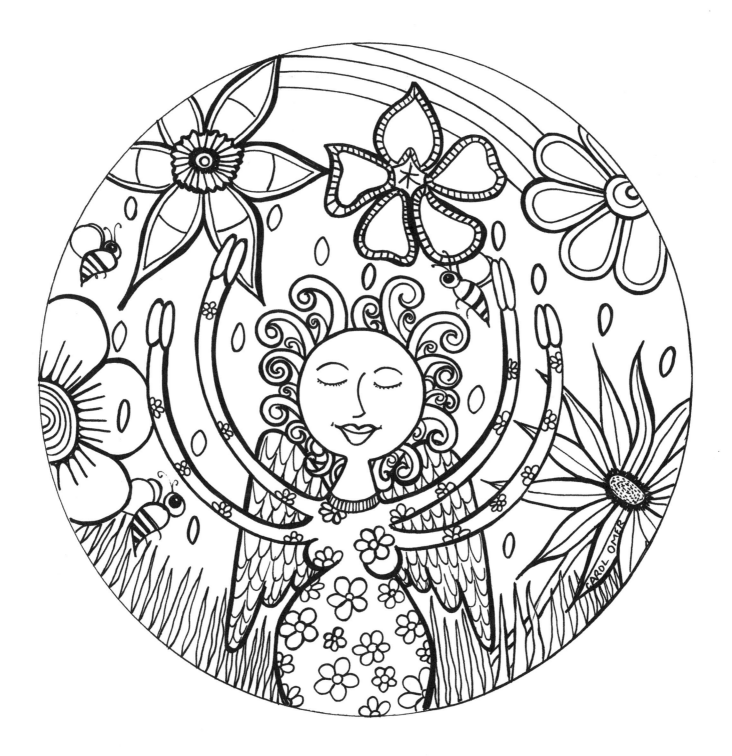

My mind can transform the difficulties of life into opportunities for new growth.

Look at the words imagination and genius: *I-magi-nation* and *geni-us*.

The magi and the geni are the wish makers and manifesters in the world of magic and possibilities. Within each and every one of us there is a vast array of untapped magic and a geni waiting to be unleashed.

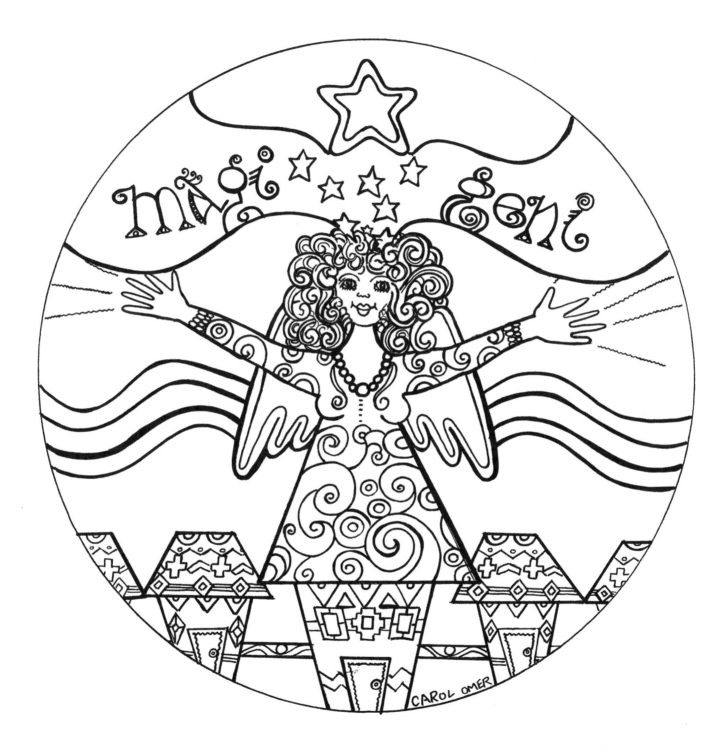

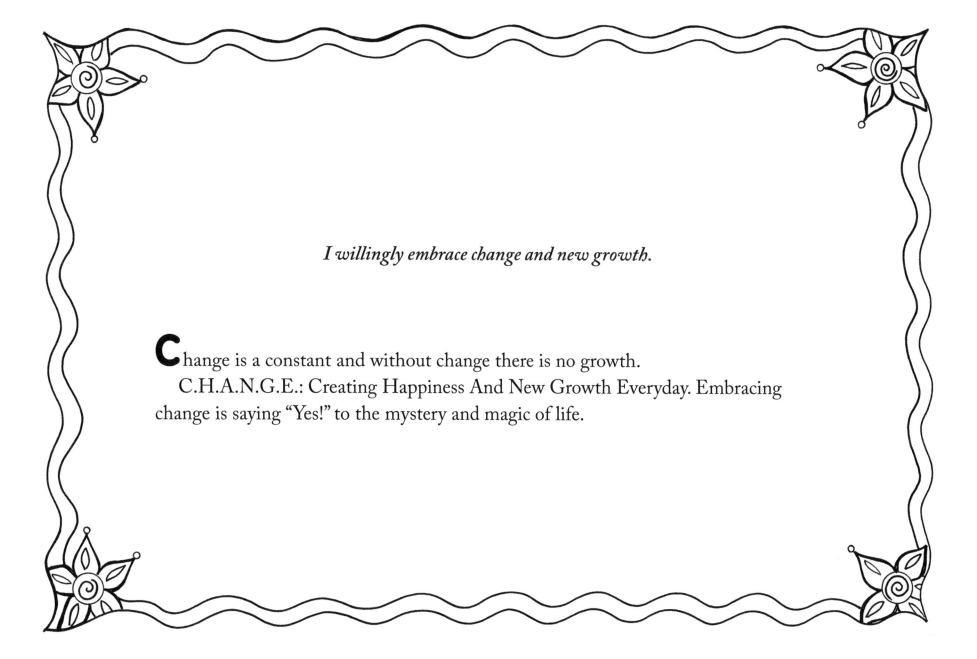

I willingly embrace change and new growth.

Change is a constant and without change there is no growth.

C.H.A.N.G.E.: Creating Happiness And New Growth Everyday. Embracing change is saying "Yes!" to the mystery and magic of life.

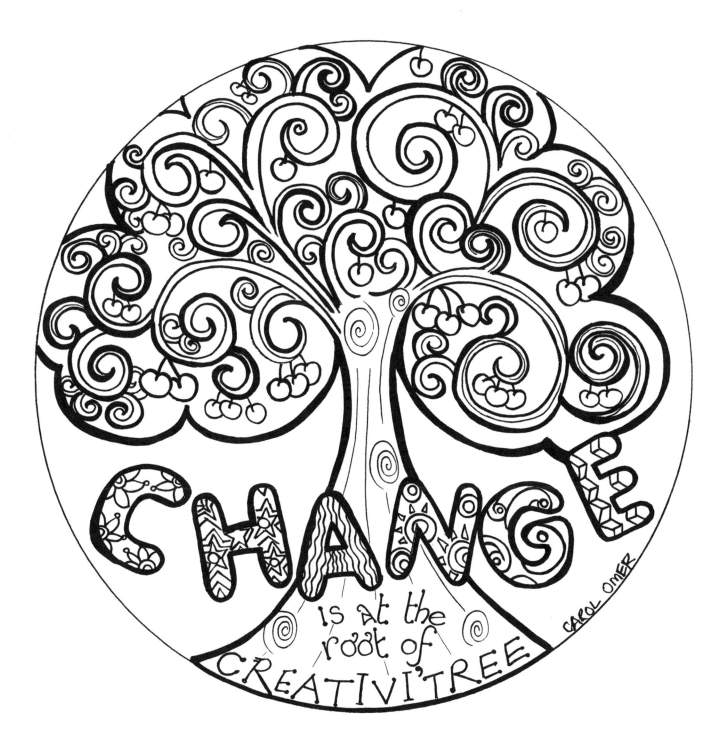

I choose thoughts that enrich peace of mind and harmonious relationships.

Life is like the ocean. There are high tides and low tides. Rough seas and smooth sailing.

In an instant the weather can change to bright and sunny or dark and broody. Gratitude and a positive mind-set are powerful oars that steer our boat into safe and peaceful waters.

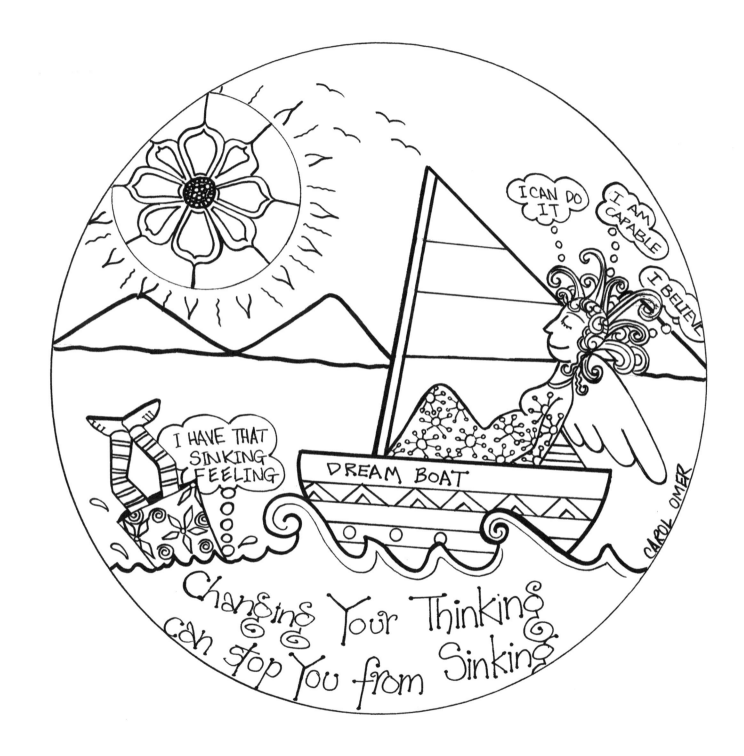

The beam of a lighthouse stays strong and focused amidst the howling wind and rain.

The lighthouse is a beacon in the storm. The clear, unwavering light steers ships away from danger.

By cultivating our inner light to the extent that it is not adversely affected by the thunder and lightening around us, we become empowered to let our own light shine.

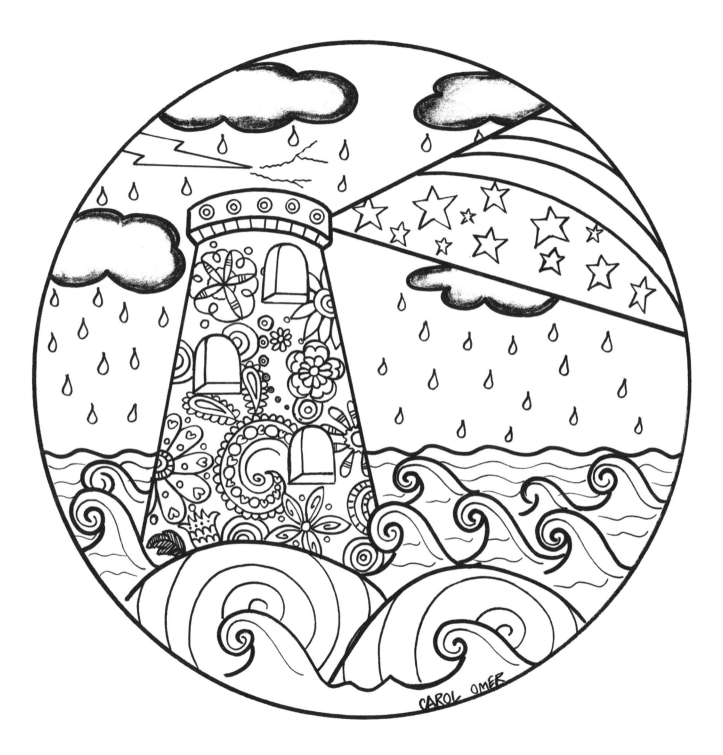

CAROL OMER

I release the patterns that no longer serve me,
and I create dynamic new patterns to replace them.

We are born into a pattern-coded universe and we learn by repetition. Patterns enable us to make sense of the world around us.

Throughout life we develop patterns of behaviour that are often unconscious, and we are unaware of their enormous influence over everyday life. By taking an inventory of the recurring themes in our life, we can understand how our uniquely personal patterns play out and how to begin to create the kind of positive patterns that we want.

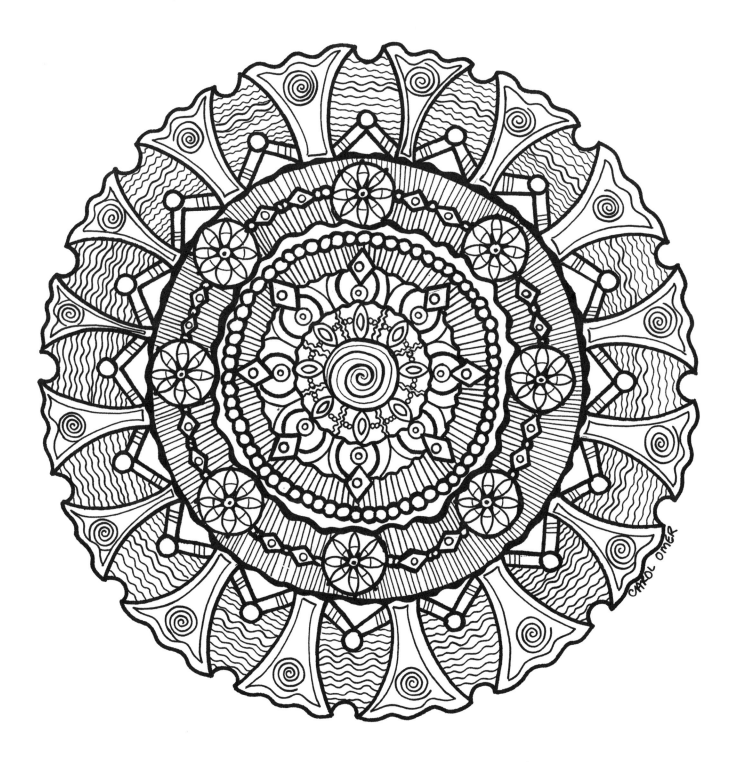

I recognise when I am becoming overwhelmed or overworked,
and I make time to restore my balance and peace of mind.

The word *balance* is made up of two words: it is an anagram of *Can* and *Able*.
When there is balance we can and are able to function with health and vitality. Creating balance by caring for the body, mind, spirit, and emotions enriches our life and empowers our role as a co-creator.

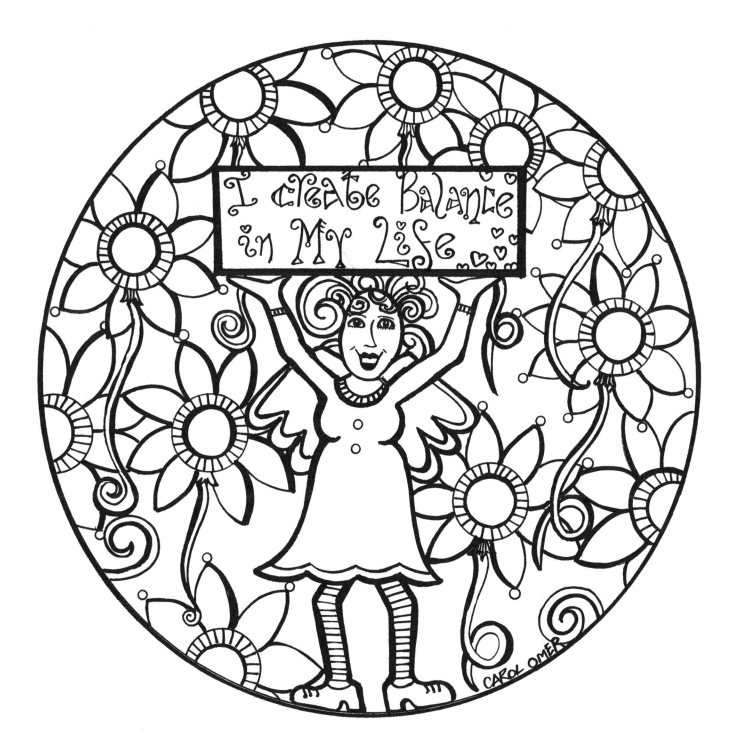

I embrace the healing and restorative power of nature to replenish my body, mind, spirit, and emotions.

Twenty-first century life is different that any other time in history.

Many of us have become disconnected from nature as concrete, cars, technology, and work have taken the place of spending time outdoors. By spending time amongst the elements of earth, water, fire, and air, we reconnect with the very source of who we are as Mother Earth's children.

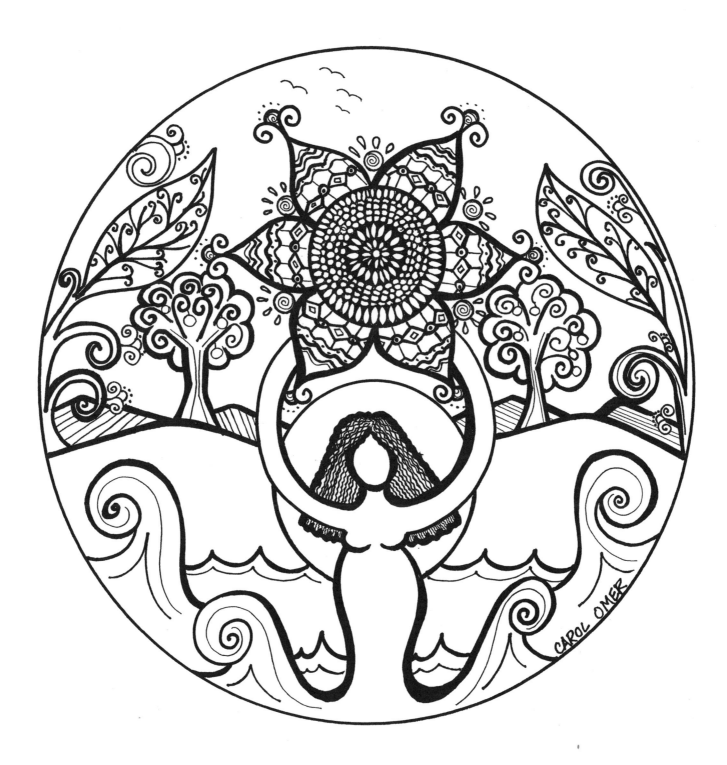

The more I shape and cultivate my mind, the better shape my life will be.

The word *shape* has many common uses: the shape of things to come, getting back in shape, and shape up or ship out.

The thoughts we think on a daily basis shape our actions and impact our emotions. Ask yourself this question: What shape are my thoughts in today?

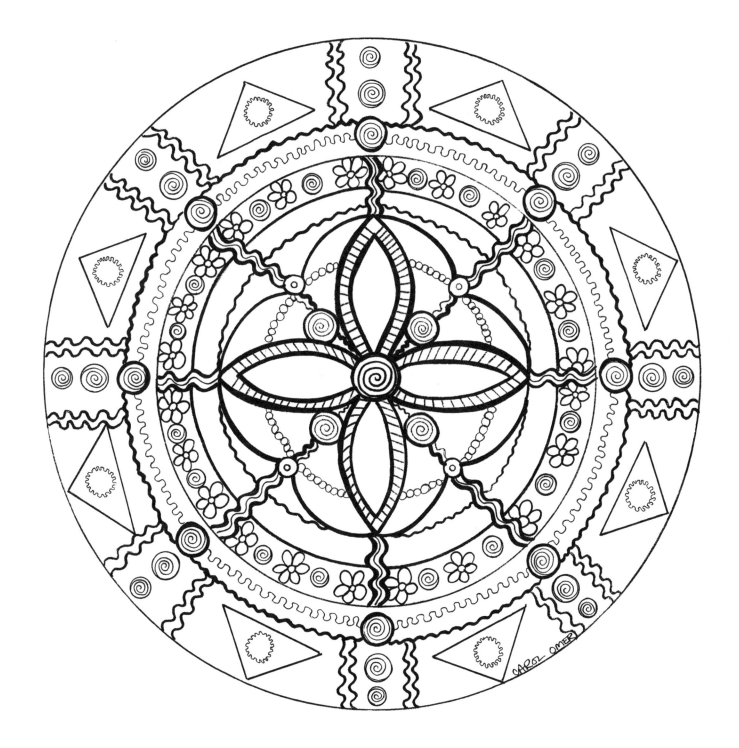

Life deals us many cards, and as a co-creator I choose to design some cards of my own and pen them with interesting ideas.

When life deals the cards we were not expecting, we can choose to use creativity and imagination to draw on a positive outlook.

By designing our own deck of cards and using them to give shape and color to new ideas, we are saying "Yes!" to a life of prosperity.

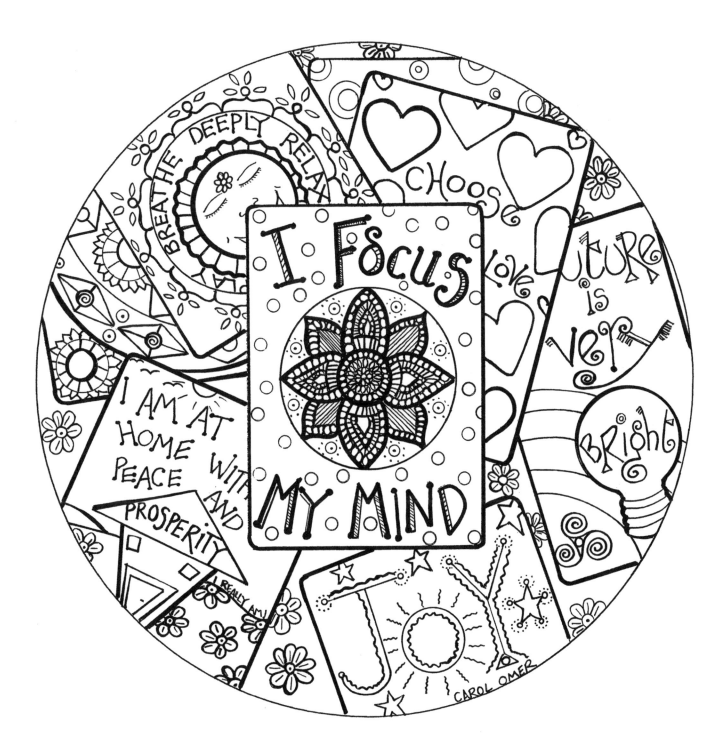

When I am fully present, I return to the center as my breathing relaxes.
My brain and busy mind are soothed by peaceful alpha waves.

To be fully present in the moment releases the mind chatter from past events and speculations about the future.

Coloring a mandala is an open-eyed meditation. Each stroke of the pencil moves us into a relaxed and restful state of mind.

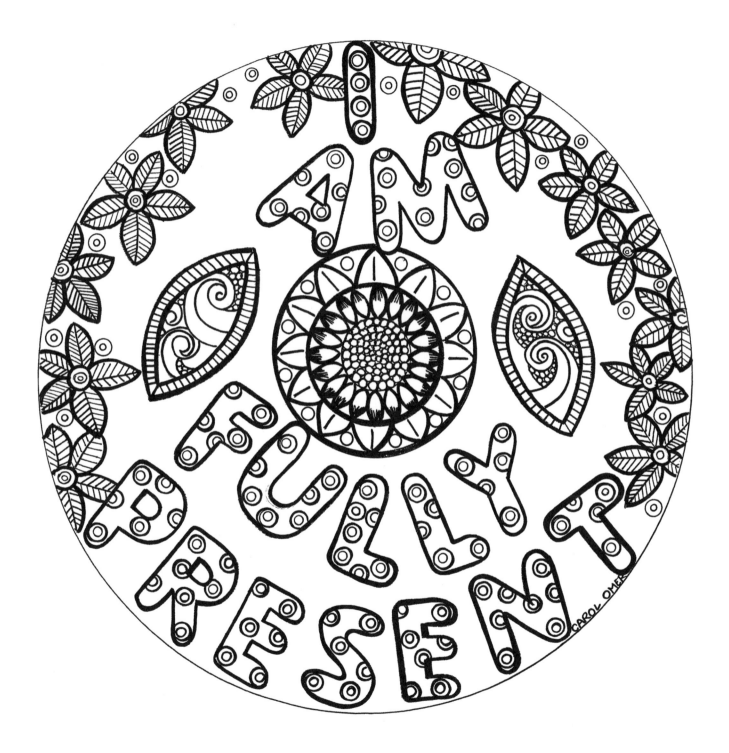

I embrace the circle and the circle embraces me.

The circle or mandala is at the heart of the universe. The Sun, Moon, Mother Earth are all circular.

The cells in our body, our eyes, mouth, ears, and nostrils are all mandalas. We grow in the circle of the womb, and prior to birth there are no sharp lines or boxes in our world. Creating with mandalas returns us to the circle, the place of wholeness.

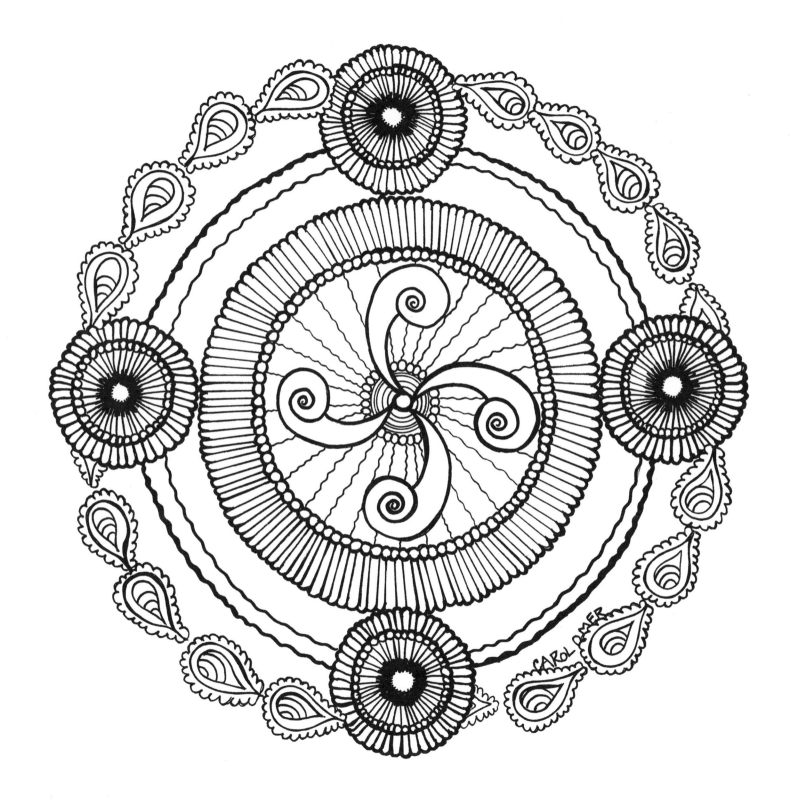

Today I celebrate my inner light and radiate optimism, vision, and new possibilities.

The English language is peppered with rich metaphors that draw on the inspiration of sun and light: bright ideas, bright and breezy, beaming smile, radiant, delightful, enlightenment, light hearted, sunny disposition, seeing the light, and illumination.

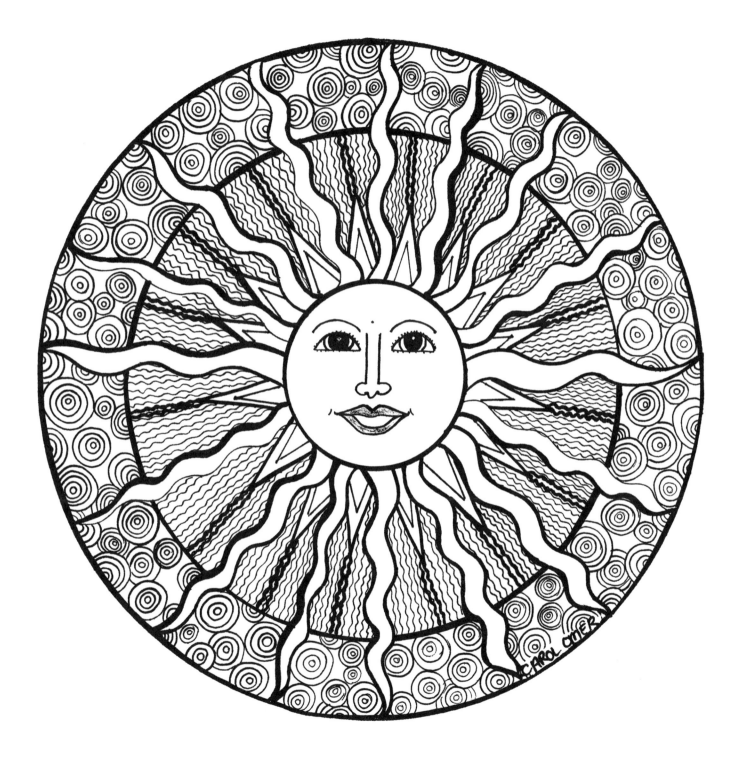

I connect with my intuitive self and listen to my inner wise woman.

Wisdom: The insights, compassion, and knowledge that are developed from experience and knowing thy self.

By sharing the wisdom of our own unique journey with others we make an important contribution to the lives of others. How do you share your knowledge and experience with others?

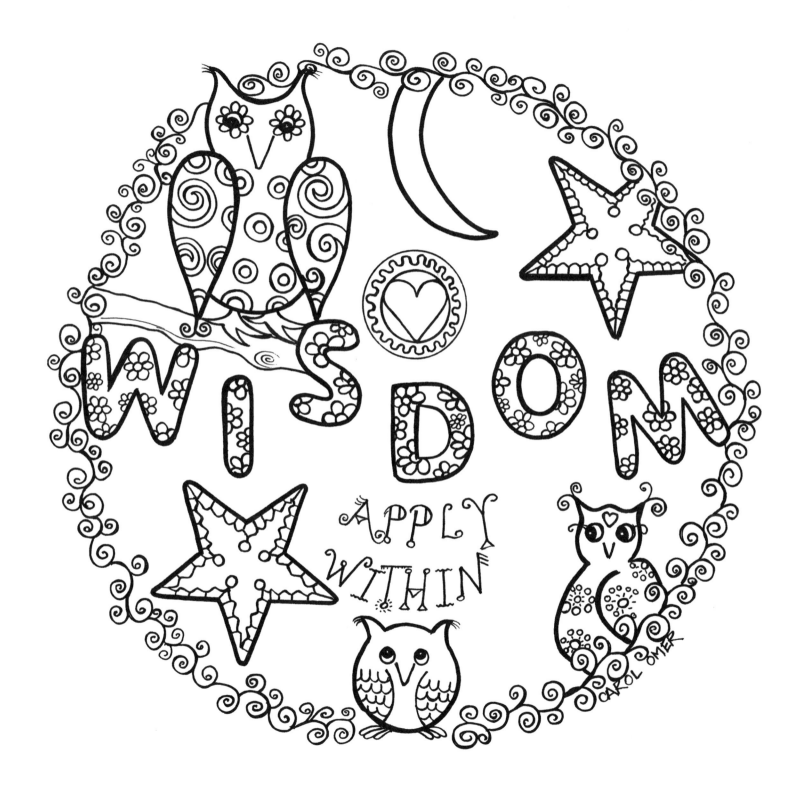

I celebrate the women in my life, and recognize the importance of
coming together in circles of creativity and conversation.

The women in our life are our sisters, mothers, daughters, aunts, cousins, grand-mothers, and friends. Sometimes the women are adversaries who are in our life to teach us an important lesson.

By recognizing and honoring the feminine divine, we reconnect with the Goddess, Mother Earth, and Mother Nature.

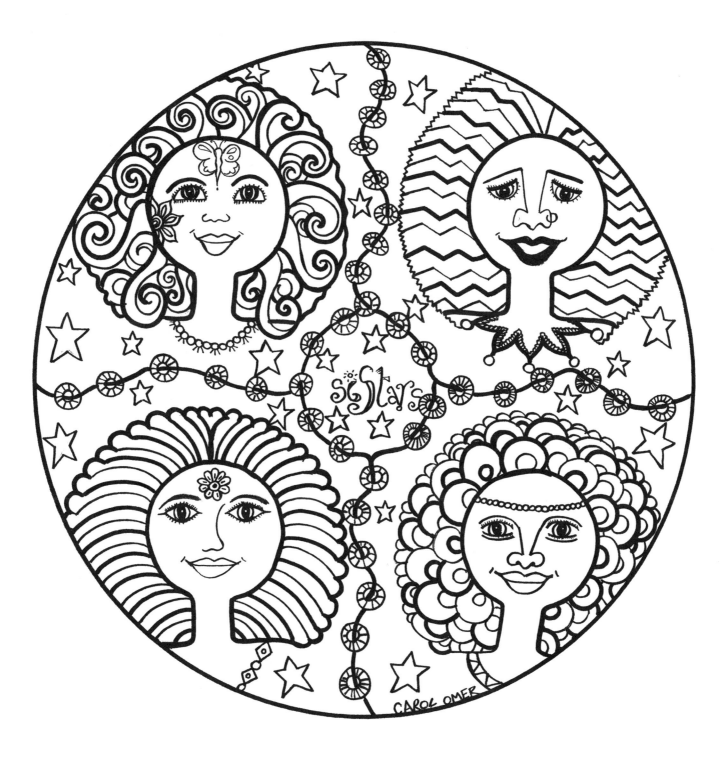

Find simple ways to create a big difference.

What is this?'. It is the simple shape that transforms impossible to I'm possible! In a world where doom and gloom are the preoccupation of the media, slipping one of these' in there will transform doom and gloom to do'om and glo'om. Now that will make a very big difference!

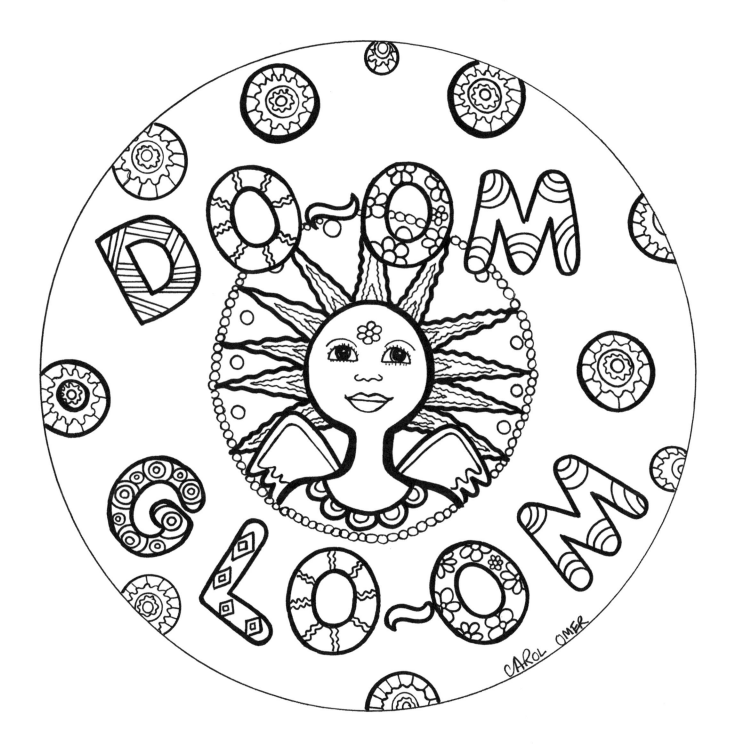

I joyously, courageously celebrate all that I am and all that I am becoming.

Did the caterpillar know she would be reborn with new wings and new horizons?
Within each and every one of us are new stories and untapped potential that unfolds as we embark on new pathways. The Transformation Woman, also known as Butterfly Woman, is always emerging and expanding as we travel through the amazing journey of life.

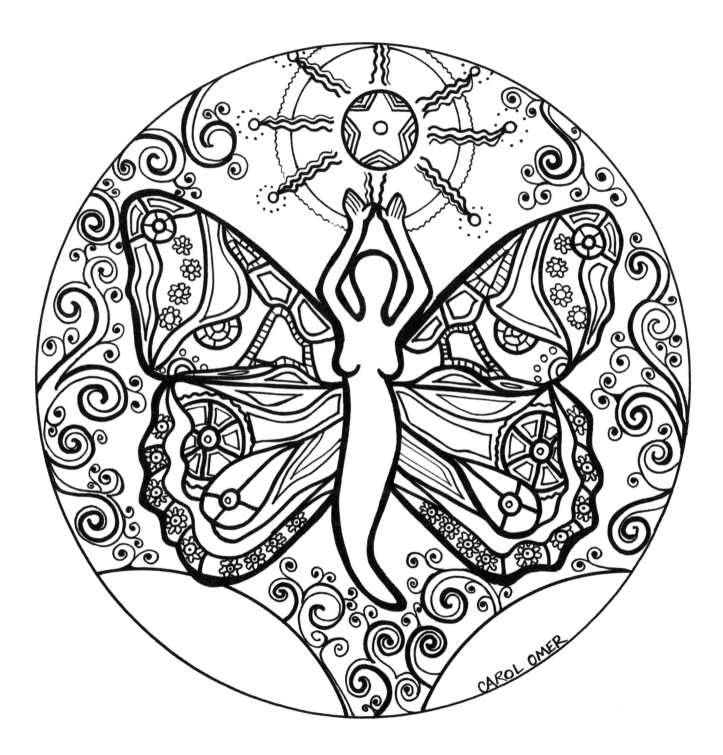

Wonderful things are now in my hands.

As I meditate on the blessings in my life, I celebrate my hands as the instruments that care for my loved ones, comfort my friends, and co-create with the world around me.

My hands write my goals, hopes, and dreams, and draw my vision for the future.

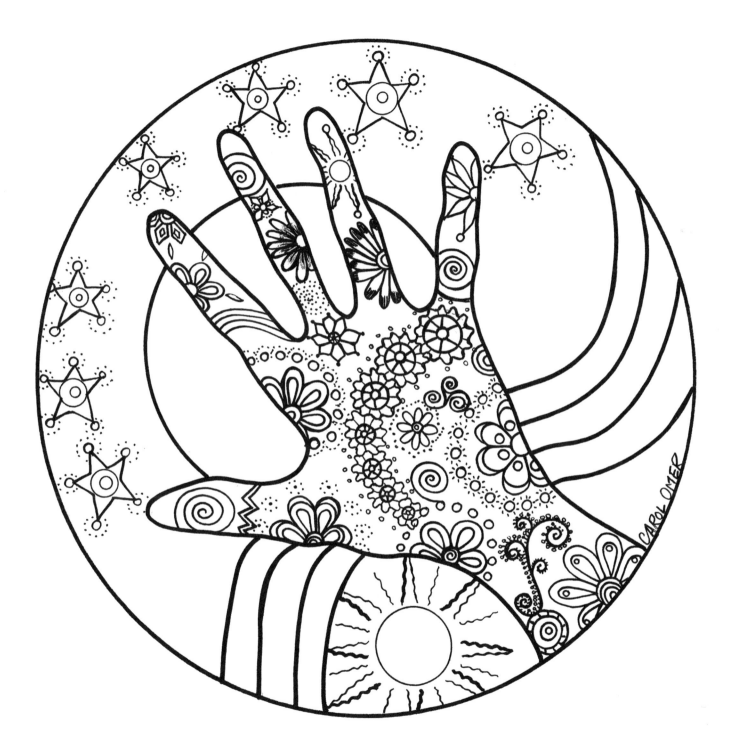

To bead or not to bead, that is the question.

Beads are found across all cultures, going back through the ages. They can be made of stone, bone, glass, metal, clay, and shells. They are 3-D mandalas: round shapes that are colored and decorated.

Sitting in a women's circle and rolling air-dry clay beads is a wonderful, relaxing pastime.

As each bead is rolled, focus on the things you are grateful for and what you would like to create in your life. Paint your beads in gorgeous, luscious colors, and thread them together in celebration of your unique, creative self.

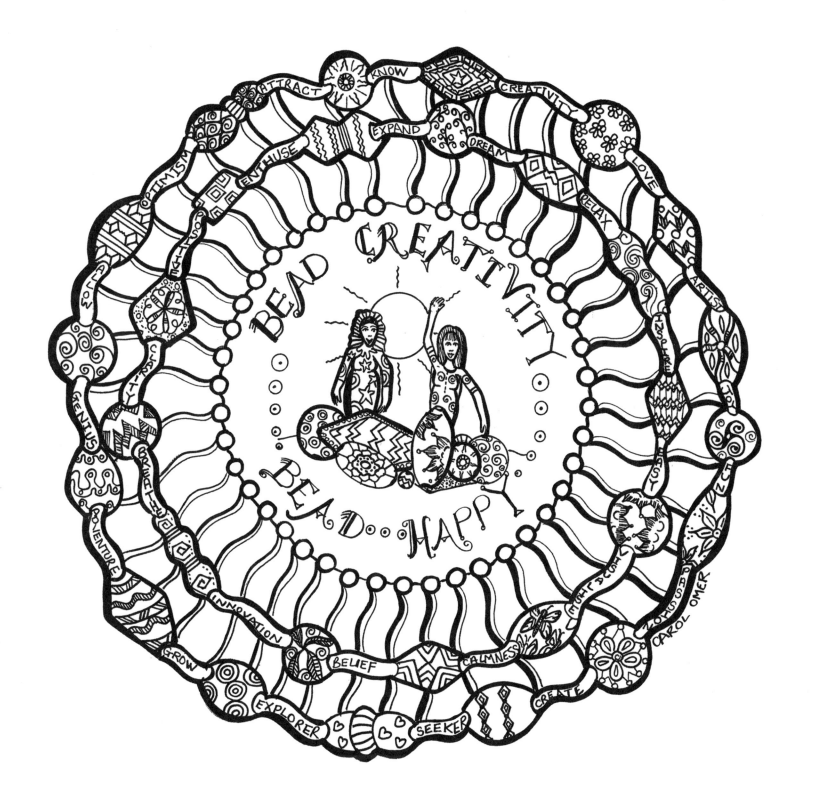

Wonderful ideas and creativity are unleashed as I allocate time for simple pleasures and spend time with like minded friends.

Follow the eight easy steps and you will see how easy it is to make your own mandala. You will see that each pattern within the circle builds on the one before it.

It is very relaxing to get out pencils and blank paper, and make sure you share your fun with family and friends. See how easily you can become a mandala artist!

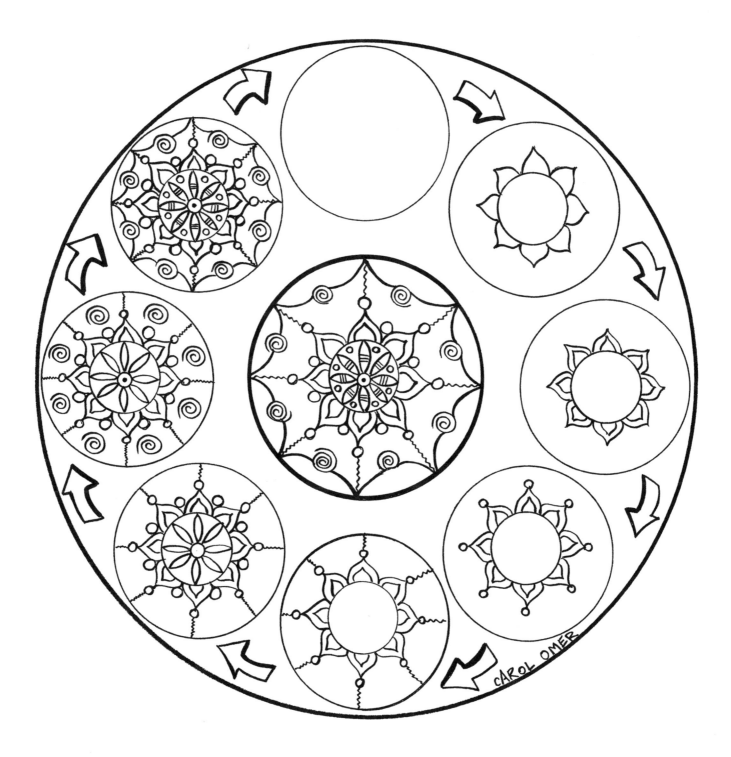

CAROL OMER

I fully embrace my creativity, and identify three creative goals that enrich and empower my capacity to manifest my dreams.

Albert Einstein once said: "Imagination is more important than knowledge." By setting a creative goal we give our imagination the opportunity to play and explore innovative ways to manifest in the physical world.

Perhaps you would like to begin to write your life story or plan a holiday to somewhere you have never been? You may like to plant a row of sunflowers that represent growing new connections and opening new doors, or create an art journal to give shape and color to your dreams.

Whatever creative goals you set make sure to put action to them and you will enjoy the serendipity and opportunities that arise as a result.

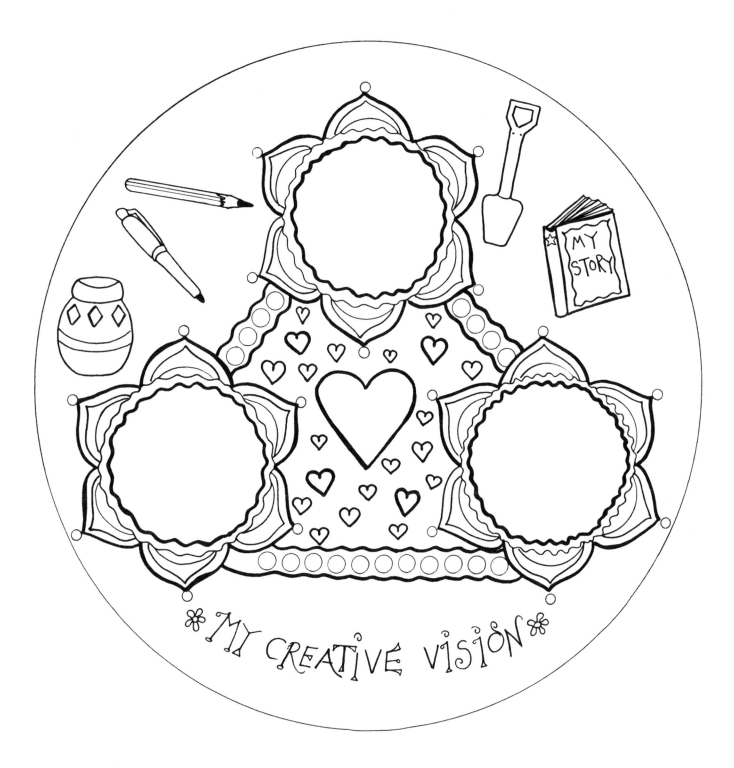

ACKNOWLEDGEMENTS

The Big Girls Little Coloring Book was envisioned and created in Adelaide, South Australia, which is traditional Aboriginal country, home of the Kaurna people. I would like to acknowledge the Kaurna community and pay my respect to the richness of Aboriginal culture and the inspiration it has been for creating women's coloring circles, using art to share our stories.

During the development of this book my wonderful partner, David Salomon, and I were married. I would like to thank my husband for his unconditional love and unshakeable belief in my work. I am very blessed and those blessings are transformed into my art.

Big thank you also to my family who are always there for each other. My parents Ken and Maureen Omer, who always gave us word games and art and craft supplies during our childhood. Their witty humor has been handed down to the next generation!

Special thanks to the RunTrue women's group members: Meg, Joy, Madeleine, and Naomi for invoking the Quirky Angels and their encouragement in creating this book.

Last, though far from least, a big thank you to Yami, Junipurr, and Purrly, my feline friends and companions who were by my side and at my feet during the many hours of creative solitude during the creation of *The Big Girls Little Coloring Book*.

BEYOND WORDS

Beyond Words Publishing
20827 N.W. Cornell Road, Suite 500
Hillsboro, Oregon 97124-9808
503-531-8700 / 503-531-8773 fax
www.beyondword.com

First Beyond Words trade paperback edition June 2016

Beyond Words Publishing is an imprint of Simon & Schuster, Inc. and the Beyond Words logo is a registered trademark of Beyond Words Publishing, Inc.

For more information about special discounts for bulk purchases, please contact Beyond Words Special Sales at 503-531-8700 or specialsales@beyondwords.com.

Manufactured in the United States of America

10 9 8 7 6 5 4 3 2 1

ISBN 978-1-58270-621-4

The corporate mission of Beyond Words Publishing, Inc.: *Inspire to Integrity*